DRAWING
ON GRIEF
EXPLORING LOSS THROUGH CREATIVITY

Leaping Hare Press

First published in 2022 by Leaping Hare Press, an imprint of The Quarto Group.

The Old Brewery, 6 Blundell Street
London, N7 9BH,
United Kingdom
T (0)20 7700 6700
www.Quarto.com

A catalogue record for this book is available from the British Library.

ISBN 978-0-7112-7252-1
Ebook ISBN 978-0-7112-7253-8

10 9 8 7 6 5 4 3 2 1

Commissioning editor Monica Perdoni
Cover and interior illustrations by Kate Sutton
Design by Renata Latipova

Printed in China

DRAWING ON GRIEF

EXPLORING LOSS THROUGH CREATIVITY

KATE SUTTON

HELLO,

I'D JUST LIKE TO SAY, I'M SO, SO SORRY FOR YOUR LOSS, FROM THE DEPTHS OF MY HEART. I HOPE THIS LITTLE BOOK OFFERS YOU A PLACE TO REMEMBER THE PERSON WHO DIED, A PLACE TO TELL YOUR STORY & EXPLORE YOUR GRIEF, ALL IN A CREATIVE WAY. MY MUM, KATH, DIED TEN YEARS AGO NOW AND IT'S BEEN A LONG AND MESSY DECADE TO SAY THE LEAST. SHE FELT LIKE THE CENTRE OF MY WORLD AND LEARNING TO LIVE WITHOUT HER FELT SO INCREDIBLY PAINFUL, DIFFICULT, and SURREAL.

IT SEEMED NO ONE REALLY TALKED ABOUT GRIEF BEING LIKE this. I'D HEARD ABOUT WORKING THROUGH THE

STAGES OF GRIEF LIKE it COMES TO AN END, BUT I FOUND THE REALITY TO BE VERY DIFFERENT. IT'S EVER CHANGING AND NEVER ENDS. I WISH I'D KNOWN SOME OF THIS. I AM SURE YOU ARE ALL TOO AWARE THAT GRIEF CAN FEEL LIKE A VERY LONELY PLACE. I HOPE THAT HAVING THIS SPACE TO EXPLORE YOUR GRIEF and LOSS WILL HELP IN MAKING YOU FEEL less ALONE.

I BEGAN DRAWING ABOUT MY MUM AND MY GRIEF A COUPLE OF YEARS AGO and IT HELPED ME SO MUCH; NOT ONLY WAS IT A WAY TO GET SOME THINGS OUT OF ME AND ONTO THE PAGE BUT IT ALSO FELT LIKE A WAY

TO TELL MY STORY AND MAKE SENSE OF MY LOSS. THERE IS SOMETHING VERY HEALING ABOUT HAVING YOUR STORY HEARD, AND DOING THESE DRAWINGS FELT LIKE THAT— AS IF I WAS FINALLY EXPRESSING WHAT I WAS FEELING AND HAD BEEN THROUGH. I CAN ONLY HOPE THAT YOU CAN FIND SOME OF THAT IN THIS BOOK.

I DIDN'T ALWAYS FIND IT EASY TO EXPRESS MYSELF VERBALLY, SO DRAWING BECAME INVALUABLE FOR GETTING MY FEELINGS OUT OF ME, and HELPED ME SHARE WHAT I WAS GOING THROUGH. A PICTURE CAN SAY SO MUCH, SOMETIMES MORE THAN WORDS. THE THERAPEUTIC BENEFITS OF DRAWING AND CREATING ARE HUGE AND THIS, TIED IN WITH THE FACT THAT YOU ARE DRAWING ABOUT YOUR FEELINGS

AND EXPERIENCES AROUND GRIEF and LOSS CAN HAVE PROFOUND EFFECTS.

THROUGHOUT THE BOOK, I HAVE SHARED MY STORY IN ILLUSTRATED FORM. I HOPE THESE DRAWINGS OFFER SOME COMFORT. I KNOW GRIEF IS DEEPLY PERSONAL BUT ALSO STRANGELY UNIVERSAL.

I HAVE CREATED A BOOK THAT I WOULD HAVE LIKED TO HAVE READ AND WORKED THROUGH WHEN I WAS LOST IN PAIN – A BOOK THAT WOULD HAVE MADE ME FEEL *less* ALONE.

HOW TO USE this BOOK

To represent the unpredictable nature of bereavement, there is no particular order to this book. You may choose to start at the beginning, but you are also free to dip in and out whenever you like. The main themes covered in the prompts revolve around remembering who died, how they died, your grief and looking after yourself. You can also use the index at the end of the book to find specific activities to your needs.

You may FIND some of the pages don't resonate with you at all and that is completely fine. You are free to ignore the prompt and use the page any way you wish.

For lots of the prompts, I invite you to draw. I understand that this may not feel very comfortable for you and you are obviously free to write instead, but I would encourage you to draw if you can. Try and draw without judgment or worrying about the outcome, like you may have done as a child.

This is a space for you, and it doesn't matter what it looks like. Getting in the FLOW whilst drawing and being creative has its own huge array of healing benefits.

Some pages are mindful drawing exercises to allow yourself a break from your grief. Even if you only have 5 minutes, it's 5 minutes for you, to lose yourself in the page.

You may need extra pages for certain things, and for some you may choose to revisit again and again, such as writing a letter to the loved one you have lost. I often go back to this or telling the story of how they died because you and your grief evolve over time, and your perspective can often change too. Also, for pages like gratitude and little wins, you may wish to have a little book dedicated to such things and create a daily habit of noting them down.

I hope you find some comfort in these pages. Sending all my love. Kate xxxx

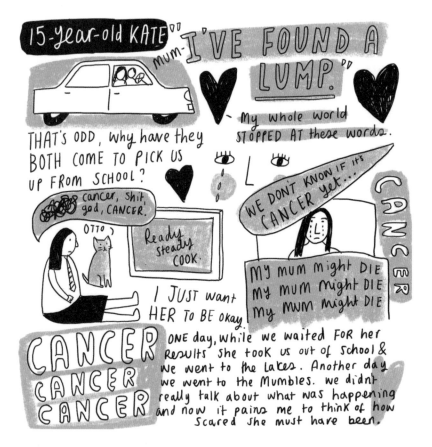

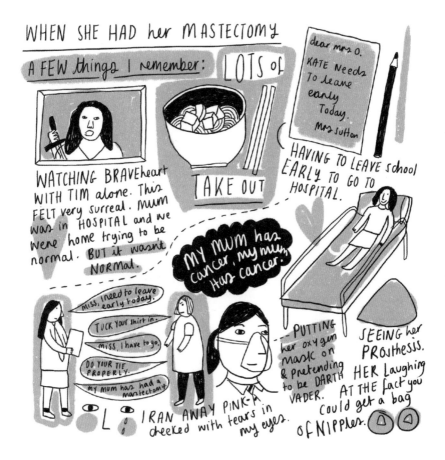

WHEN SHE GOT ALL HER HAIR CUT OFF.

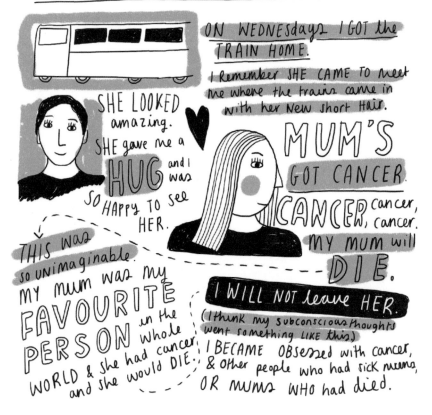

ON WEDNESDAYS I GOT the TRAIN HOME.

I Remember SHE CAME TO meet me where the trains came in with her New short Hair.

SHE LOOKED amazing.

SHE gave me a HUG and I was SO HAPPY TO see HER.

MUM'S GOT CANCER. CANCER cancer, cancer. MY mum will DIE.

THIS was so unimaginable. My mum was my FAVOURITE PERSON in the whole WORLD & she had cancer and she would DIE.

I WILL NOT leave HER.

(I think my subconscious thoughts went something LIKE this.)

I BECAME OBSESSED with cancer, & other people who had sick mums, OR mums WHO had died.

THE-FIVE-YEAR mark

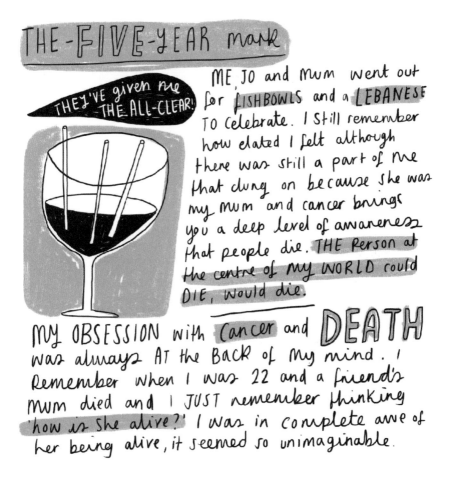

THEY'VE given me THE ALL-CLEAR!

ME, JO and MUM went out for FISHBOWLS and a LEBANESE TO celebrate. I still remember how elated I felt although there was still a part of me that clung on because she was my mum and cancer brings you a deep level of awareness that people die. THE Person at the centre of MY WORLD could DIE, would die.

MY OBSESSION with cancer and DEATH was always AT the BACK of My mind. I remember when I was 22 and a friend's mum died and I JUST remember thinking 'how is she alive?' I was in complete awe of her being alive, it seemed so unimaginable.

THINGS I DID TO AVOID GRIEF

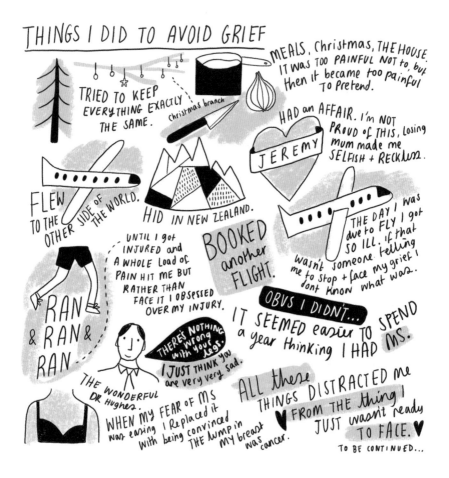

TRIED TO KEEP EVERYTHING EXACTLY THE SAME.

Christmas branch

MEALS, Christmas, THE HOUSE. IT was TOO PAINFUL NOT to, but then it became too painful To Pretend.

HAD an AFFAIR. I'm NOT PROUD of THIS. Losing mum made me SELFISH + RECKLESS.

JEREMY

FLEW TO THE OTHER SIDE OF THE WORLD.

HID IN NEW ZEALAND.

BOOKED another FLIGHT.

UNTIL I got INJURED and A WHOLE load of PAIN hit me but RATHER THAN FACE IT I OBSESSED OVER MY INJURY.

RAN & RAN & RAN...

THE DAY I was due to FLY I got SO ILL. if that wasn't someone telling me to stop + face my grief I don't know what was.

OBVS I DIDN'T...

IT SEEMED easier TO SPEND a year thinking I HAD MS.

THERE'S NOTHING wrong with your legs. I JUST THINK you are very very sad.

THE WONDERFUL DR Hughes.

WHEN MY FEAR OF MS was easing I Replaced it with being convinced THE lump in my breast was cancer.

ALL these THINGS DISTRACTED me FROM THE thing I JUST wasn't ready TO FACE. ♥

TO BE CONTINUED...

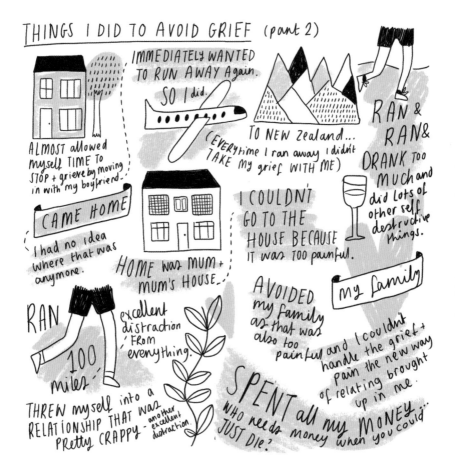

WHAT WAS THEIR NAME? WRITE or DRAW IT in a BEAUTIFUL WAY.

'THE DEATH OF A BELOVED is AN AMPUTATION.'

C.S. LEWIS

DOES IT feel like you've lost a part of yourself?
DRAW OR WRITE ABOUT IT HERE.

DRAW OR WRITE ABOUT WHO HAS DIED.

HOW DID THEY DIE? USE these PAGES
TO DRAW or WRITE ABOUT IT.

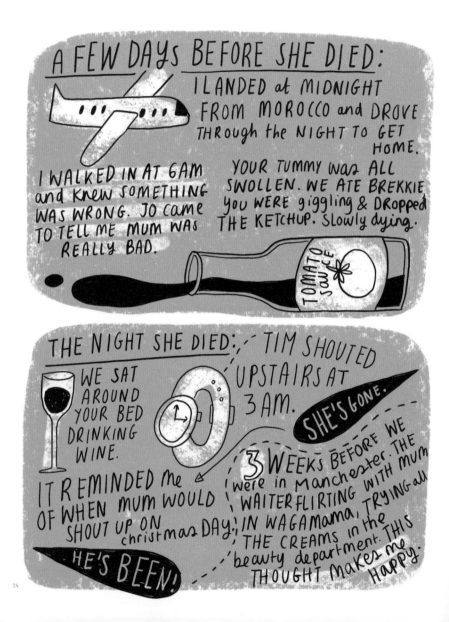

CAN YOU DRAW ANY MEMORIES
FROM THE TIME LEADING UP TO THEIR DEATH?

THINGS I REMEMBER FROM the DAY she DIED.

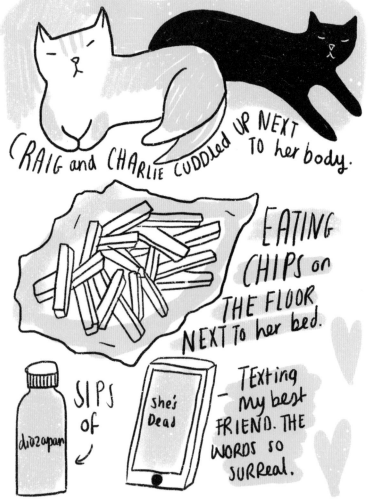

CRAIG and CHARLIE CUDDLED UP NEXT TO her body.

EATING CHIPS on THE FLOOR NEXT To her bed.

SIPS of diazapam

she's Dead

TExting my best FRIEND. THE WORDS so SURReal.

WHAT DO YOU REMEMBER FROM THE DAY YOU LOST THEM?

HOW DID YOU hear ABOUT THEIR DEATH?

DRAW the state of YOUR heart
THE DAY THEY Died.

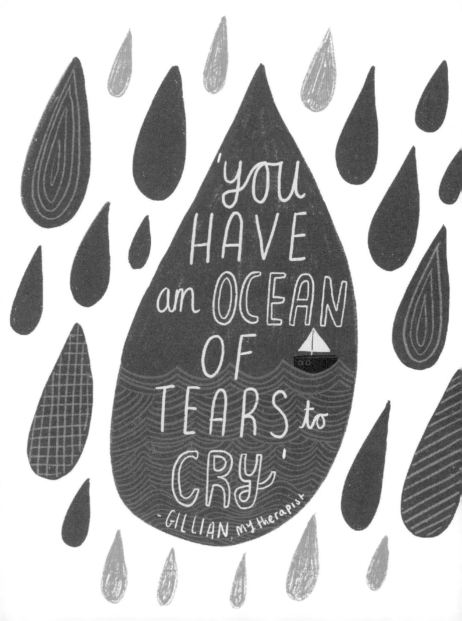

TAKE SOME PENCILS and FILL this
PAGE with tears.

IS THERE A PARTICULAR SEASON or
THING THAT triggers YOU MOST?
DRAW ABOUT it HERE.

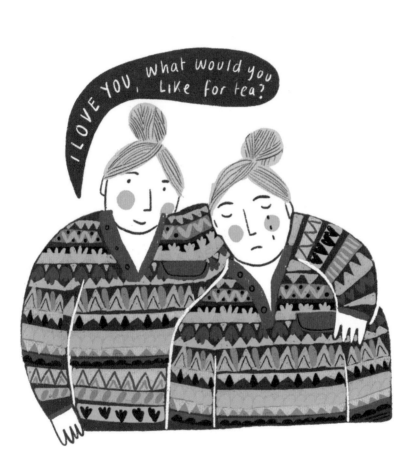

DRAW YOUR MOST COMFORTING MEAL

It MAY be something that reminds you of them
or just something that feels like a big hug.

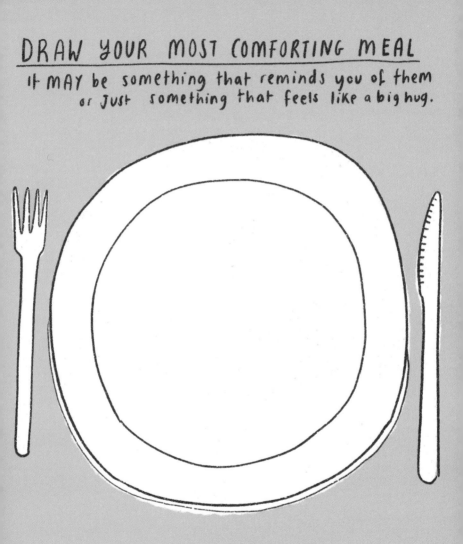

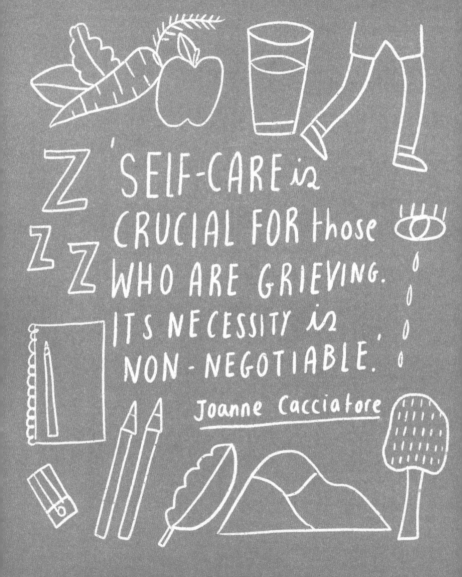

'SELF-CARE is CRUCIAL FOR those WHO ARE GRIEVING. ITS NECESSITY is NON-NEGOTIABLE.'

Joanne Cacciatore

FILL this PAGE WITH DRAWINGS OF things
You CAN DO to take CARE of YOURSELF.

I WASN'T STRONG enough TO HOLD MYSELF and I FELT LIKE I DIDN'T HAVE anyone TO CATCH ME WHILE I FELL APART. SO I DIDN'T, ON an UNCONSCIOUS LEVEL. I KEPT IT IN TIGHT and IT CAME OUT IN VERY PAINFUL, STRANGE, MESSY WAYS.

DOES ANYONE ELSE SAY HI TO EVERY ROBIN THEY ever see? MAKE YOURSELF A CUP OF TEA and COLOUR IN THIS PAIR.

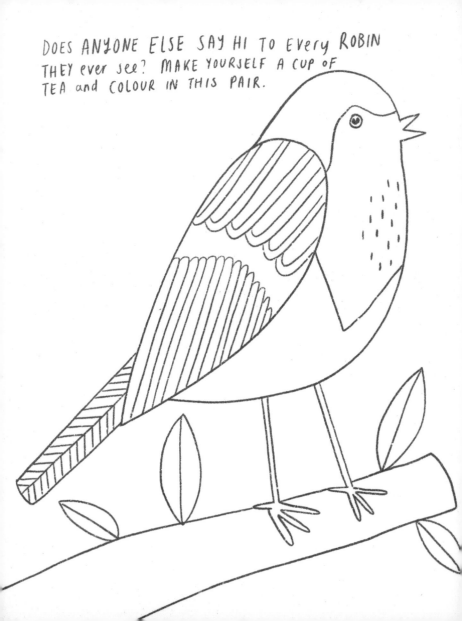

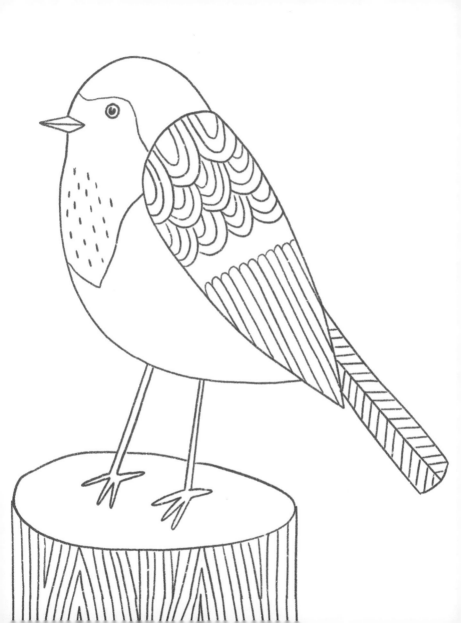

TODAY'S LITTLE WINS

DRAW or write
three things you
achieved or
overcame today.

TODAY's LITTLE WINS

DATE:

IS THere A SONG THAT REMINDS YOU OF THEM?
ARE you able to play it NOW and FILL these pages
with ANYthing that COMES UP?

GRIEF NEEDS OUR ATTENTION.
IF YOUR GRIEF WAS A CHARACTER
KNOCKING AT YOUR DOOR, What Would
IT LOOK LIKE? WHAT WOULD YOU SAY to
IT? WHAT WOULD IT SAY TO YOU?
DRAW this SCENARIO.

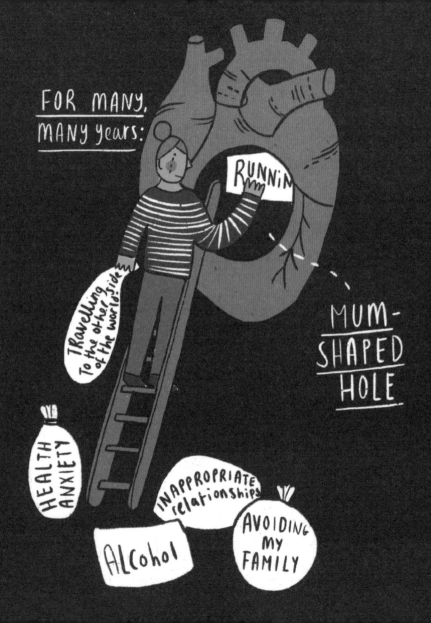

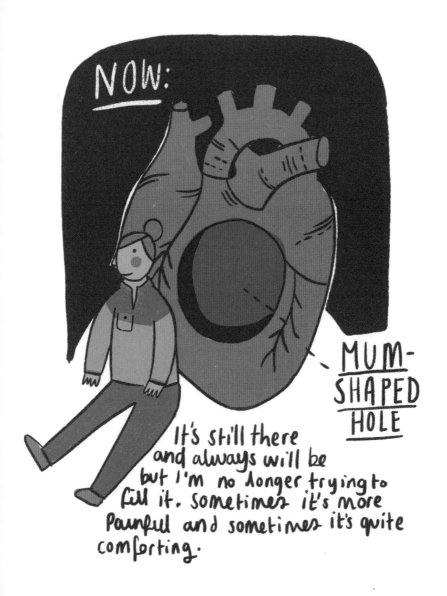

WRITE a letter TO YOURSELF.

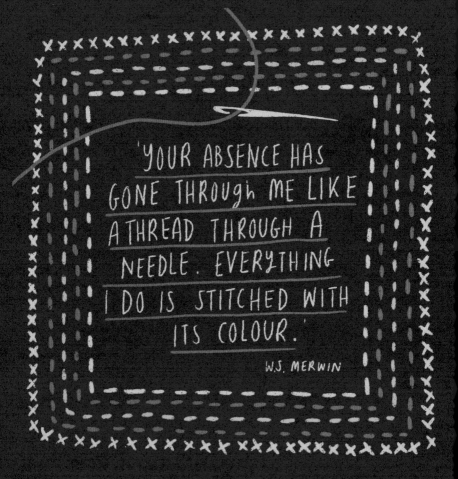

'YOUR ABSENCE HAS GONE THROUGH ME LIKE A THREAD THROUGH A NEEDLE. EVERYTHING I DO IS STITCHED WITH ITS COLOUR.'

W.S. MERWIN

WHAT might you be FILLING THE HOLE IN YOUR heart WITH?

WRITE a LETTER to THEM.

THREE QUESTIONS YOU WISH YOU COULD ask THEM...

THREE things you would like to tell them...

WHAT DOES YOUR HEART FEEL LIKE TODAY?
COLOUR, DRAW, WRITE, as you wish.

Where are you feeling the grief in your body? What Colour is it? What does it look like?

DRAW A MEMORY
OF THEM that MAKES
YOU SAD.

DRAW a MEMORY OF Them THAT makes you LAUGH.

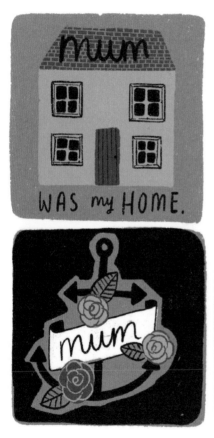

mum

WAS my HOME.

WHEN SHE DIED, MY WHOLE world collapsed. I FELT LIKE I was alone, Lost at sea for many years. . .

I HAD No anchor.

mum

THESE strange FEELINGS of being UNTETHERED and NOT having an ANCHOR STILL BUBBLE up in ME FROM TIME to TIME.

DRAW or WRITE ABOUT A TIME YOU FELT
LOST or UNTETHERED.

PICK a COLOUR that REPResents
YOUR EMOTIONS TODAY. FILL these
PAGES WITH DOODLES, MARKS OR
WORDS IN THAT COLOUR.

BUTTERFLIES feel so comforting and HOPEful. Make yourself A BREW and fill these PAGES with them.

MY EX-PARTNER DESCRIBED me
AS A LIMPET AFTER my mum DIED.

FIG 1: limpet

a small sea creature that is found clinging
tightly to Rocks.

I was so lost, scared, untethered, anchorless. Desperate to be attached to something, it felt like survival. Now when I look back I have so much love for that little limpet.

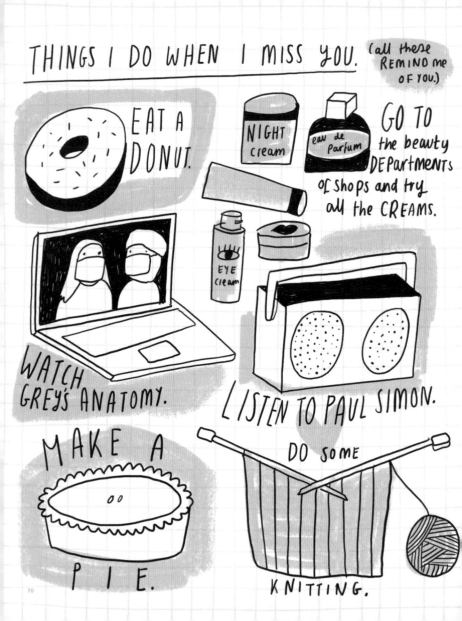

WHERE CAN YOU FIND comfort WHEN YOU miss THEM?

DRAW a dream YOU had about them.

Mum held us all together. After she died,
we fell apart. We had to find a new
way to relate to one another.

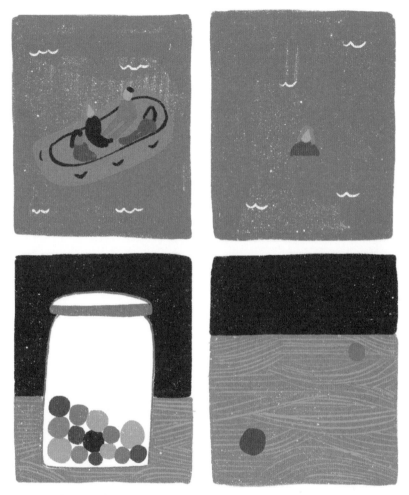

For many years it was too painful to be with my family, her absence was even more apparent when we were together.

HOW Have your relationships been affected by your LOSS?
USE THESE PAGES To DRaw or WRITE ABOUT it.

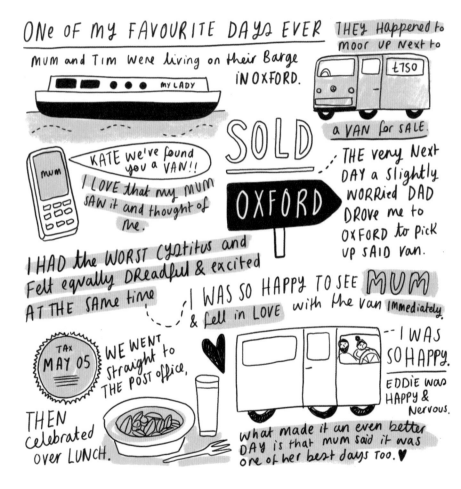

DRAW a FAVOURITE memory OF YOUR LOVED ONE HERE.

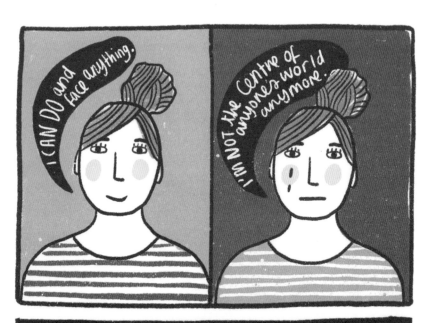

MOST OF THE time, being motherless & single makes me feel strong, independent, and resilient. BUT occasionally it makes me feel very alone. ALONE on a deeper level that I can't REALLY EXPLAIN.

CAN YOU DRAW ABOUT A TIME YOU FELT VERY ALONE?

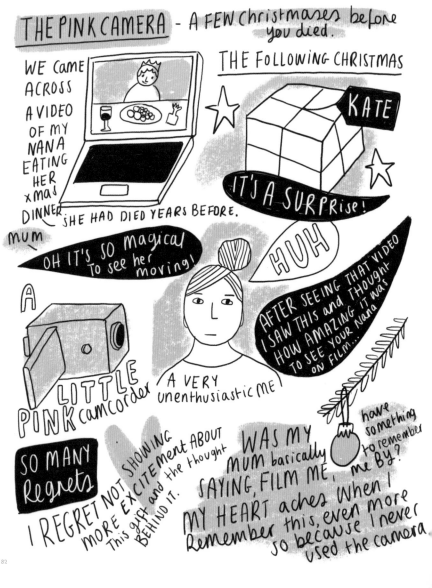

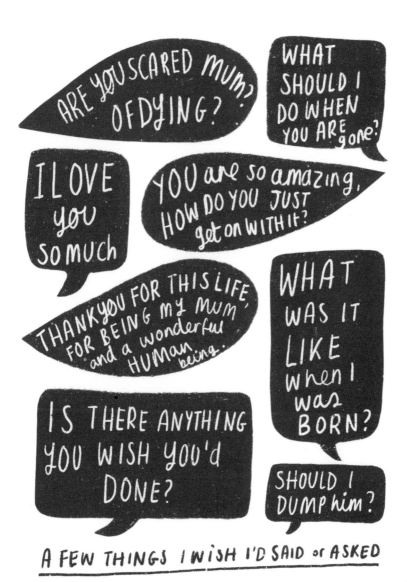

FILL these CLOUDS WITH ANY REGRets.

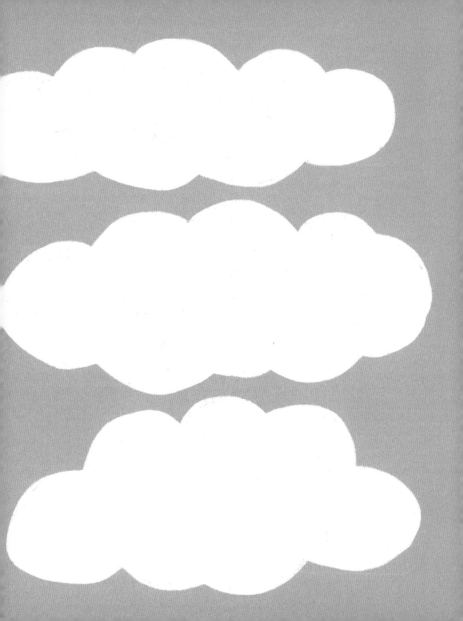

DRAW WHAT YOU MAY BE PRESENTING ON THE
OUTSIDE VS WHAT YOU ARE FEELING INSIDE.

FILL these PAGES WITH YOUR ANGER.

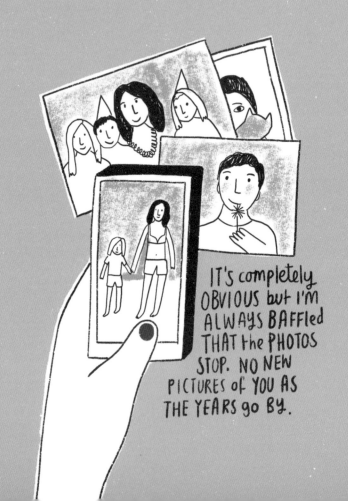

IT'S completely OBVIOUS but I'M ALWAYS BAFFLED THAT the PHOTOS STOP. NO NEW PICTURES of YOU AS THE YEARS go BY.

PICK A FEW OF YOUR FAVOURITE PHOTOS OF THEM and DRAW THEM HERE.

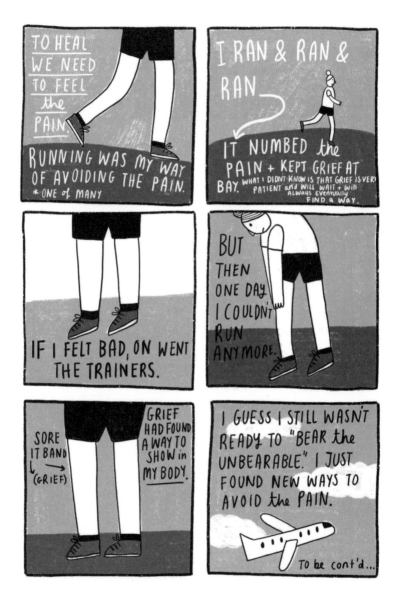

HAVE YOU FOUND YOURSELF DOING
anything TO AVOID the PAIN?
DRAW about IT HERE.

ARE there any words or Quotes that you take comfort in? USE this space to DRaw them out in a decorative way.

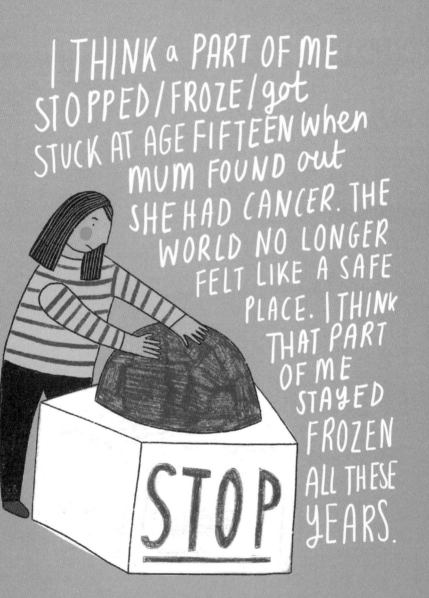

DO YOU FEEL LIKE YOU GOT STUCK ANYWHERE? DRAW OR WRITE ABOUT IT HERE.

FILL these JARS with SOME MEMORIES YOU DON'T WANT TO FORGET.

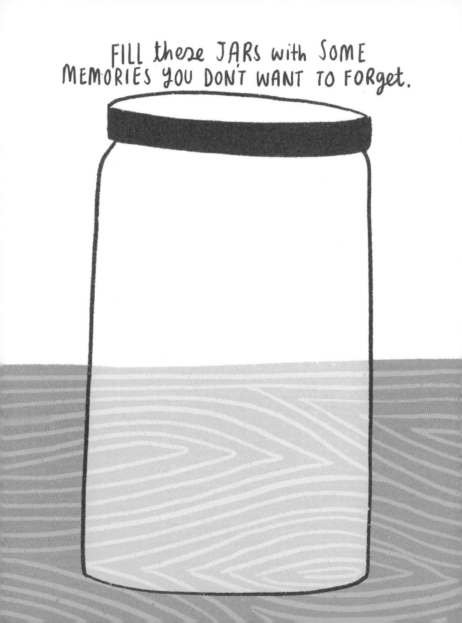

FILL these PAGES with small DRAWINGS of ANY PLACES, SMELLS, things that REMIND you of them.

'IT'S LIKE THE GRIEF HAS been COVERED OVER WITH SOME KIND of BLANKET. IT'S STILL THERE, BUT the SHARPEST EDGES ARE... MUFFLED' anne TYler

DRAW ABOUT A TIME it's felt LIKE THE BLANKET WAS WHIPPED OFF.

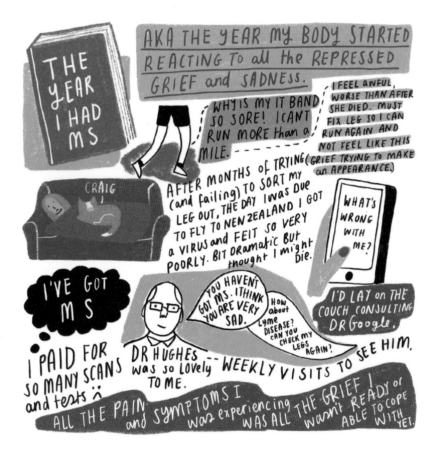

THE YEAR I HAD MS

AKA THE YEAR MY BODY STARTED REACTING TO all the REPRESSED GRIEF and SADNESS.

WHY IS MY IT BAND SO SORE! I CANT RUN MORE than a MILE.

I FEEL AWFUL, WORSE THAN AFTER SHE DIED. MUST FIX LEG SO I CAN RUN AGAIN AND NOT FEEL LIKE THIS (GRIEF TRYING TO MAKE an APPEARANCE.)

CRAIG

AFTER MONTHS OF TRYING (and failing) TO SORT MY LEG OUT, THE DAY I was DUE TO FLY TO NEW ZEALAND I GOT a VIRUS and FELT SO VERY POORLY. BIT DRAMATIC BUT thought I might die.

WHAT'S WRONG WITH ME?

I'VE GOT MS

YOU HAVENT GOT MS. I THINK YOU ARE VERY SAD.

HOW About Lyme DISEASE? CAN YOU CHECK MY LEGS AGAIN?

I'D LAY ON THE COUCH CONSULTING DR Google.

I PAID FOR SO MANY SCANS and tests :(

DR HUGHES was so LOVELY TO ME.

WEEKLY VISITS TO SEE HIM.

ALL THE PAIN and SYMPTOMS I was experiencing WAS ALL THE GRIEF I wasn't READY or able TO COPE WITH YET.

HAVE YOU HAD any PHYSICAL MANIFESTATIONS OF grief IN YOUR BODY? DRAW or WRITE ABOUT THEM HERE.

ARE there any objects that really remind you of them? DRAW TWO of them here and write what they mean to you.

I THINK I HELD ON TIGHT TO SADNESS TO FEEL a CONNECTION TO MY MUM. I'D FIND myself IN SITUATIONS & RELATIONSHIPS THAT WOULD FEED my SADNESS.

IF I WAS SAD and HURTING
I STILL HAD her. IF I'M NOT in
PAIN DOES IT MEAN the LOVE
HAS GONE?

I DIDN'T KNOW WHO I WAS WITHOUT
HER, and I DIDN'T KNOW WHO
I WAS WITHOUT the SADNESS
OF HER BEING GONE.

I NO LONGER FEEL the NEED
TO LOSE MYSELF IN SADNESS TO
KEEP HER WITH ME.

I'M learning TO
LET IT GO and
I'M FINDING MY
MUM IN MYSELF.

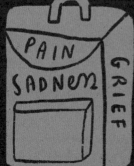

DRAW a SAFE and comforting PLACE...

GRIEF is MESSY. MAKE A MESS of THESE PAGES in any way YOU LIKE.

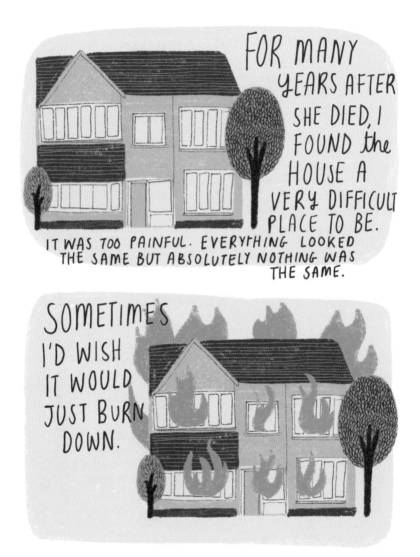

FOR MANY YEARS AFTER SHE DIED, I FOUND the HOUSE A VERY DIFFICULT PLACE TO BE. IT WAS TOO PAINFUL. EVERYTHING LOOKED THE SAME BUT ABSOLUTELY NOTHING WAS THE SAME.

SOMETIMES I'D WISH IT WOULD JUST BURN DOWN.

ARE THERE ANY SPECIFIC PLACES YOU
FIND PAINFUL or DIFFICULT? DRAW them here.

DRAW TEN things YOU HAVE DONE
THAT YOU ARE PROUD OF.

WHAT DO YOU think THEY WOULD SAY TO YOU right NOW?

DRAW ten THINGS YOU LOVE ABOUT YOURSELF.

THINGS / THOUGHTS / ACTIONS THAT help.

Things | THOUGHTS | ACTIONS THAT don't HELP

KINTSUGI is the Japanese art of mending BROKEN objects using gold. The Japanese believe that when something has suffered damage and has history, it becomes more beautiful.

MAKE these pots even more beautiful.

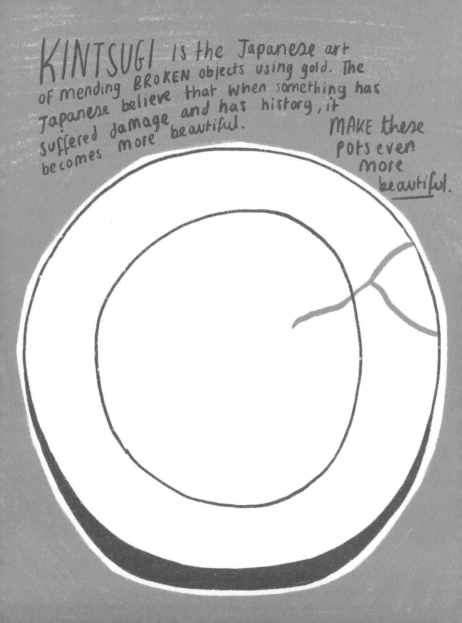

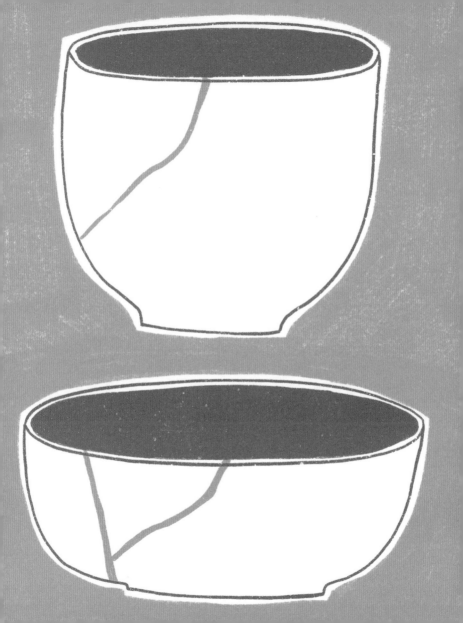

USE THIS page to EXPLORE how your sense of SELF HAS BEEN AFFECTED BY YOUR LOSS.

IT'S SO IMPORTANT TO FIND TIME FOR YOU.
What could your MAGIC HOUR LOOK LIKE?

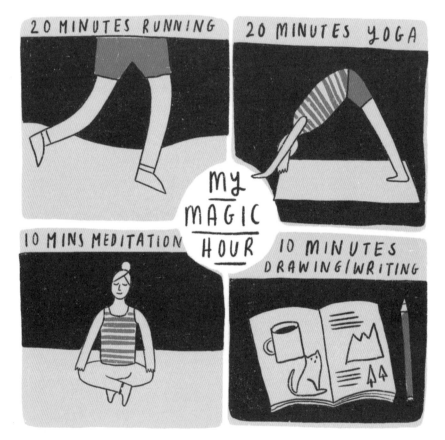

USE THIS PAGE TO DRAW or JOURNAL on whatever you are feeling right now.

USE THESE SQUARES TO TELL THEM ABOUT YOUR DAY. (LIKE a mini comic)

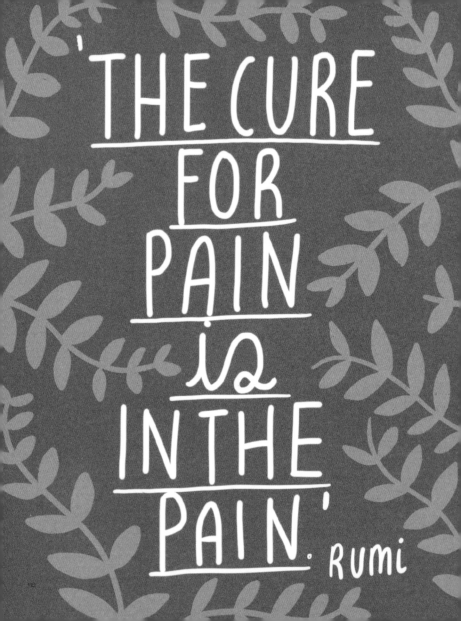

'THE CURE FOR PAIN is IN THE PAIN.' rumi

DRAW YOUR FEARS.

TAKE YOURSELF ON A WALK and BE MINDFUL of THE WORLD AROUND YOU. WHEN YOU GET HOME DRAW FOUR THINGS YOU SAW.

DATE: _____

TAKE YOURSELF ON A WALK and BE MINDFUL OF THE WORLD AROUND YOU. WHEN YOU GET HOME DRAW FOUR THINGS YOU SAW.

DATE: _____

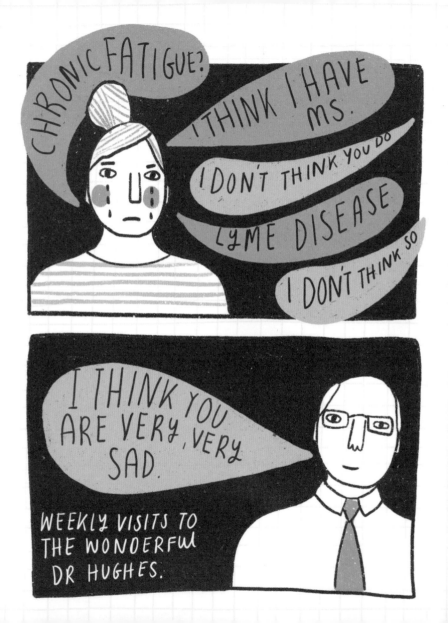

'OUR ISSUES ARE IN OUR TISSUES.'

TARA BRACH

AFTER SHE DIED I FELT QUITE FEARLESS, IN MY HEAD the WORST THING HAD HAPPENED TO ME and I WAS STILL STANDING. I DID THINGS THEN I WOULDN'T DO NOW. I WAS RECKLESS IN SO MANY AREAS of MY LIFE.

CAN YOU THINK OF ANY TIMES YOU'VE
ACTED RECKLESSLY?
DRAW or WRITE ABOUT THOSE ACTIONS HERE.

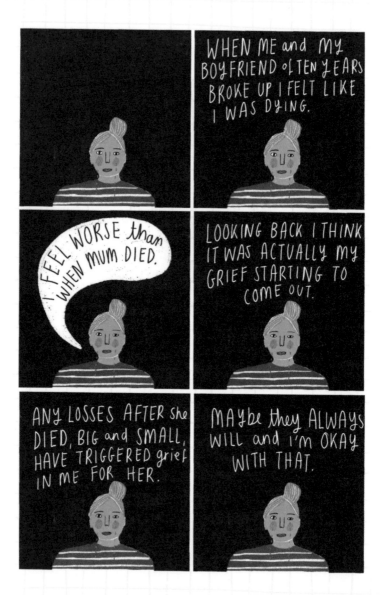

HAVE ANY NEW LOSSES BROUGHT UP OLD grief IN YOU? DRAW or WRITE about it here.

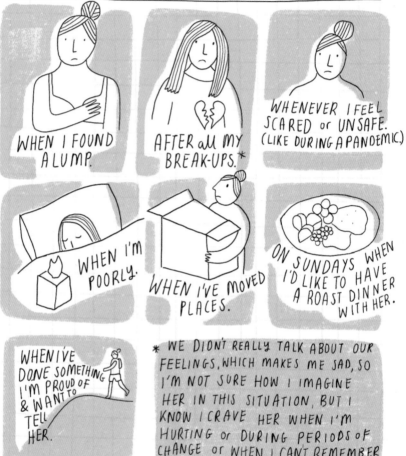

WHEN HAVE YOU MISSED them MOST?

FIVE YEARS AFTER HER DEATH

I FOUND MYSELF LYING ABOUT HOW LONG SHE'D BEEN DEAD BECAUSE I FELT I SHOULD HAVE BEEN 'BETTER' OR 'OK' BY NOW.

TODAY I'M GRATEFUL FOR:

DATE: _____ (DRAW/WRITE SIX things)

TODAY I'M GRATEFUL FOR:

DATE: _____ (DRAW/WRITE SIX things)

AUGUST

AM I DEPRESSED OR IS IT GRIEF? IT'S TEN YEARS SINCE MY MUM DIED and MY DEAR CAT CRAIG is POORLY. I'M IN THE HOUSE MY MUM DIED WATCHING HIM DIE. SO MANY FEELINGS COMING UP.

DRAW ABOUT A TIME something has triggered your GRIEF.

A LETTER to my RECENTLY BEREAVED SELF

Hello you, I'm here to TELL YOU THAT IT DOES GET easier, BUT IT WILL TAKE A LONG TIME. YOU ARE DOING SO WELL; YOU ARE SURVIVING SOMETHING YOU THOUGHT WAS UNSURVIVABLE.

YOU WILL FEEL KIND OF OKAY ON ONE level, SWEETHEART - BUT REALLY THAT'S BECAUSE THE GRIEF is BEING SQUISHED DOWN UNTIL you ARE READY TO COPE.

YOU WILL feel ANGRY, Resentful and IRRITABLE A LOT OF THE TIME.

you'll RUN LOTS, TO THE POINT OF INJURY, WHEN YOUR BODY CAN NO LONGER TAKE THE STRESS OF RUNNING MIXED WITH ALL THE REPRESSED SADNESS. YOU'LL SUDDENLY FEEL A WAVE OF GRIEF and YOU'LL WANT TO SHUT IT DOWN IMMEDIATELY. IT WILL FEEL MUCH WORSE THAN AFTER SHE DIED EVEN THOUGH IT'S THREE YEARS LATER.

YOU WILL DRIFT FROM YOUR Family WHILE YOU ALL PROCESS YOUR LOSS and GRIEVE IN YOUR OWN WAYS. THIS IS SAD, BUT YOU WILL EVENTUALLY FIND A WAY BACK TOGETHER. AT TIMES YOU WILL FEEL very ALONE.

YOU WILL TRAVEL TO THE OTHER SIDE OF THE WORLD SEVERAL times, PARTLY TO DISCOVER WHO YOU ARE WITHOUT HER and PARTLY TO AVOID YOUR GRIEF.

YOU WILL DRINK LOTS, SPEND ALL YOUR MONEY and PICK ABSOLUTE IDIOTS TO HAVE RELATIONSHIPS WITH, all TO TRY and FILL THE HOLE IN YOUR HEART. THERE'S NO FILLING THAT HOLE, MY LOVE, AND THAT'S OKAY. I'M TELLING YOU TEN YEARS ON IT'S STILL THERE BUT THE DESIRE TO FILL IT HAS LEFT.

YOU WILL HAVE QUESTIONS ABOUT EVERYTHING. YOUR RELATIONSHIP WITH HER, WHO SHE WAS – and IT WILL FEEL DIFFICULT and CONFUSING AS YOU WILL NEVER GET THE CHANCE TO FIND OUT. WHEN YOU MEET SOMEONE WHO KNEW HER, YOU'LL CRAVE TO HEAR ABOUT her, WHAT was SHE LIKE WHEN SHE WAS YOUNGER and HOW SHE FELT. YOU'LL WANT TO KNOW HER IN WAYS THAT ARE NO LONGER POSSIBLE.

YOU WILL feel SO, SO LOST AND HAVE ABSOLUTELY NO CLUE WHO YOU ARE.

YOU'LL FORGET HER VOICE and PEOPLE WON'T TALK ABOUT HER SO OFTEN, BUT SHE'S ALWAYS INSIDE US, LOVE. IT WILL GET EASIER, I PROMISE. IT WILL ALWAYS HURT, and YOU WILL ALWAYS LOVE HER, BUT IT WON'T ALWAYS FLOOR YOU.

YOU'LL FIND A WONDERFUL THERAPIST CALLED GILLIAN WHO HELPS YOU MAKE SENSE OF THINGS.

THERE WILL be LOVELY MOMENTS OF JOY AMONG THE CRAP.

YOU WILL FIND A LITTLE HOME IN YOURSELF, and SHE WOULD BE SO, SO PROUD.

ALL MY LOVE, KATE xxxx

INDEX

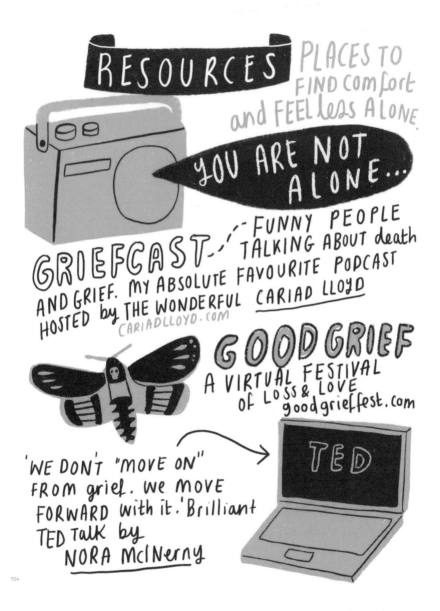

RESOURCES PLACES TO FIND COMFORT and FEEL less ALONE.

YOU ARE NOT ALONE...

GRIEFCAST --- FUNNY PEOPLE TALKING ABOUT death AND GRIEF. MY ABSOLUTE FAVOURITE PODCAST HOSTED by THE WONDERFUL CARIAD LLOYD
CARIADLLOYD.COM

GOOD GRIEF A VIRTUAL FESTIVAL OF LOSS & LOVE
goodgrieffest.com

TED

'WE DON'T "MOVE ON" FROM grief. WE MOVE FORWARD with it.' Brilliant TED Talk by NORA McINerny

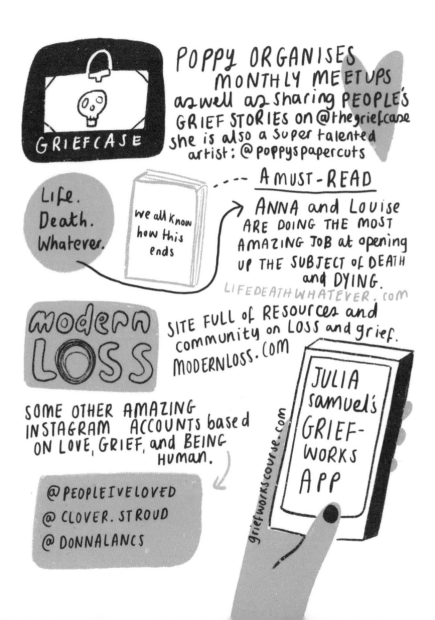

GRIEFCASE

POPPY ORGANISES MONTHLY MEETUPS az well az sharing PEOPLE'S GRIEF STORIES on @thegriefcase she is also a super talented artist: @poppyspapercuts

Life. Death. Whatever.

we all know how this ends

A MUST-READ

ANNA and LOUISE ARE DOING THE MOST AMAZING JOB at opening UP THE SUBJECT of DEATH and DYING.
LIFEDEATHWHATEVER.COM

MODERN LOSS

SITE FULL of RESOURCES and community on LOSS and grief.
MODERNLOSS.COM

SOME OTHER AMAZING INSTAGRAM ACCOUNTS based ON LOVE, GRIEF, and BEING HUMAN.

@PEOPLEIVELOVED
@CLOVER.STROUD
@DONNALANCS

JULIA samuel's GRIEF-WORKS APP

griefworkscourse.com

THE LONG GOODBYE - MEGHAN O'ROURKE

AFTER POET and CRITIC MEGHAN O'ROURKE'S MOTHER DIED OF CANCER AT 55, SHE WORKED THROUGH HER GRIEF BY WRITING. THE MOST BEAUTIFUL, HEARTBREAKING READ, I RESONATED WITH IT SO MUCH.

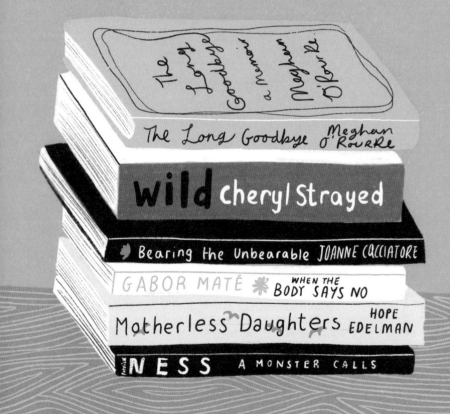

WILD - CHERYL STRAYED

'IT TOOK ME YEARS TO TAKE MY PLACE AMONG THE TEN THOUSAND THINGS AGAIN. TO BE THE WOMAN MY MOTHER RAISED...I WOULD SUFFER. I WOULD WANT THINGS TO BE DIFFERENT THAN THEY WERE. THE WANTING WAS A WILDERNESS AND I HAD TO FIND MY OWN WAY OUT OF THE WOODS.'

BEARING THE UNBEARABLE - JOANNE CACCIATORE

'...SHE NEEDED A WAY TO EXPRESS THOSE FEELINGS, SHE WANTED TO EXTERNALISE HER INTERNAL SENSE OF OBLITERATION. THIS HAPPENS SO OFTEN. "WE ARE DESTROYED, AND THEN WE SEEK TO ENACT THAT DESTRUCTION SOMEWHERE, TO GIVE IT FORM," I SAID. "AND THAT DESTRUCTION CAN COME OUT AGAINST SELF OR OTHER."

WHEN THE BODY SAYS NO - GABOR MATÉ

NOT SPECIFICALLY ABOUT GRIEF BUT A WONDERFUL BOOK BY THE AMAZING GABOR MATÉ DISCUSSING HOW REPRESSED EMOTIONS CAN LEAD TO PHYSICAL ILLNESS. IT HELPED ME MAKE SENSE OF QUITE A FEW THINGS.

MOTHERLESS DAUGHTERS - HOPE EDELMAN

MOTHERLESS DAUGHTERS REVEALS THE SHARED EXPERIENCES AND CORE IDENTITY ISSUES OF MOTHERLESS WOMEN. I DEVOURED THIS BOOK IN TWO SITTINGS, AFTER YEARS OF FEELING LOST AND ALONE IT WAS SUCH A COMFORT TO READ OF OTHER WOMEN FEELING SIMILARLY.

A MONSTER CALLS - PATRICK NESS

THIS IS THE STORY OF CONOR O'MALLEY, A 13-YEAR OLD BOY WHO IS DEALING WITH HIS MOTHER'S ILLNESS. I CRIED THROUGHOUT MOST OF THE BOOK, ABSOLUTELY AMAZING.

THE AFTERGRIEF - HOPE EDELMAN

ANOTHER EXTREMELY REASSURING BOOK BY HOPE
EDELMAN PUTTING EMPHASIS ON THE FACT THAT GRIEF
ISN'T SOMETHING WE EVER 'GET OVER'

THE BEGINNER'S GOODBYE - ANNE TYLER

I LOVE ANNE TYLER'S WRITING, A WONDERFUL BOOK
ABOUT LOVE, LOSS AND GROWTH.

The AfterGrief HOPE EDELMAN

Anne Tyler THE BEGINNER'S GOODBYE

IN SEARCH
OF SILENCE POORNA
 BELL

Grief Works Julia Samuel

TARA BRACH

We all Know how this ends ANNA LYONS
& LOUISE WINTER

IN SEARCH OF SILENCE - POORNA BELL

A BEAUTIFUL BOOK BY THE WONDERFUL POORNA BELL. 'I DIDN'T EXPECT TO FIX MY SADNESS, BUT I WANTED TO CREATE AN INNER RESERVOIR OF CALM AND QUIET THAT I COULD DRAW ON WHENEVER I WAS IN NEED.'

GRIEF WORKS - JULIA SAMUEL

A GRIEF PSYCHOTHERAPIST WHO HAS SPENT 25 YEARS WORKING WITH THE BEREAVED AND UNDERSTANDING THE FULL REPERCUSSIONS OF LOSS. THIS IS A DEEPLY COMFORTING READ FULL OF CASE STUDIES OF PEOPLE WHO ARE GRIEVING.

RADICAL ACCEPTANCE - TARA BRACH

I ONLY RECENTLY DISCOVERED TARA'S MEDITATIONS AND I'M SO GLAD I DID. THIS IS A VERY COMFORTING AND NOURISHING READ. RADICAL ACCEPTANCE IS RECOGNISING AND ACCEPTING THE PRESENT MOMENT WITH COMPASSION.

WE ALL KNOW HOW THIS ENDS -
ANNA LYONS & LOUISE WINTER

'THIS BOOK IS ABOUT LIFE AND LIVING, AS MUCH AS IT'S ABOUT DEATH AND DYING.' I ENCOURAGE YOU TO READ THIS WONDERFUL BOOK.

ACKNOWLEDGEMENTS

MUM, YOU WERE TRULY WONDERFUL & I MISS YOU SO MUCH. THANK YOU FOR THIS LIFE. MY LEVEL OF GRIEF REPRESENTS MY LEVEL OF LOVE FOR YOU.

DAD, the MOST KIND, WONDERFUL man I KNOW WHO has been THERE AT THE DROP OF A HAT WHENEVER I NEEDed.

JO, ALEC, TAN, TIM, DAD, I KNOW we all SHARED this ENORMOUS LOSS. LOVE YOU all VERY much. SORRY I DRIFTED SO FAR.

MY DEAREST FRIENDS WHO LET me STAY AT THEIR HOUSES WITHOUT QUESTION DURING THE BLEAKEST OF TIMES, WHO RAN with ME, SWAM with ME, ate CAKE WITH ME, LAUGHED with ME, CRIED with ME, SENT ME TREATS, LET ME SHARE PAGES WHEN I WAS WRACKED WITH DOUBT.

CRAIG and CHARLIE FOR being THE BEST LITTLE COMPANIONS A GIRL COULD ASK FOR, YOU BOTH BROUGHT ME SO MUCH JOY AMONG THE CRAP.

GILLIAN, without THE WORK WE'VE DONE TOGETHER this BOOK WOULDN'T EXIST, ETERNALLY GRATEFUL.

MONICA and JOE FOR TRUSTING ME COMPLETELY WITH THIS BOOK.